To You, I dedicate this first one.

"I"

www.mdliv.com

Travis Prange
Design by Kevin McCauley

©2009
ISBN 978-0-578-02822-4

Travis Prange was born in Denver, Colorado in 1982. He has been writing poetry since 1998.

Travis thanks: This collection of writings has been made possible by all of the people, places and events that have inspired every word this book contains. I never knew if this dream would come true; that so many people have urged me (for years) to compile such a thing is amazing to finally see and hold. I would not have done it without that constant support and encouragement from everyone — be it strangers, family or friends. To see this project evolve and physically come alive has been nothing short of breathtaking.

I am forever indebted to Kevin's awesome visions and designing abilities — he alone has made this book extremely special, and I'm glad that he has turned ordinary words into extraordinary pieces of art.

It would be impossible to thank you all, so I sincerely thank anyone and everyone who reads this.

For more, visit *travisprange.com*

Kevin McCauley is a graphic designer/typographer and aspring illustrator, photographer, and art director in New York, NY. He can usually be found struggling to find the time to learn all that he wants to learn.

Kevin thanks: Mom, dad, Lucky, Megan and many more. Kevin is thankful his friends aren't the type to be miffed at being left out of a thank-you. Thanks also to Travis for approaching me about this unique opportunity and for his neverending patience!

See more at *kevin-mccauley.com*

Storm **5/15/2001**
West **10/12/2004**
Only to be Passed **8/27/2005**
Midnight Dance **12/20/2005**
Red **2/8/2006**
At a Distance **4/5/2006**
Surf **4/11/2006**
Beacon **4/19/2006**
Bridge **4/20/2006**
Ouch **4/30/2006**
Untitled **4/30/2006**
Critical Silence **6/8/2006**
Sacrosanct **8/3/2006**
The Course **10/15/2006**
2 Miles **10/16/2006**
Waking up **10/22/2006**
Wordless **10/31/2006**
Continuation **11/11/2006**
Whispering Forever **11/19/2006**
Fractures of a Distant Memory **12/2/2006**
Kiss **1/13/2007**
Miami **2/10/2007**
The Source **3/25/2007**
Half Life of Sense **4/16/2007**
Zero **4/18/2007**
Departure **5/9/2007**
Gray **7/19/2007**
Blooms **7/19/2007**
Grand.Father.Time **7/27/2007**
Fracture of Eternity **8/5/2007**
These Summer Days **8/5/2007**
Gears of Life **8/6/2007**
Collapse **8/8/2007**

STORM

so much depends upon
the silver reflected snowflakes
descending into the cold midnight air
assembling in a whisper

Walk out of the door and find
A railing to lead you along the path
Only between the apartments and behind
Along the concrete, in a big hunk of slab

To the balcony, confronted with copper
Gripping the rail to keep from falling
Watching the downtown disappear after supper
Among the bright pastels raining

Into the horizon they go
As the sun surrenders to darkness
The city fights back, providing its glow
And the shadows come out to play

My quest does not end at the horizon
Nor does it stop when the sun fades
My dream lies out West
That is where I will venture to

Way out West.

ONLY TO BE

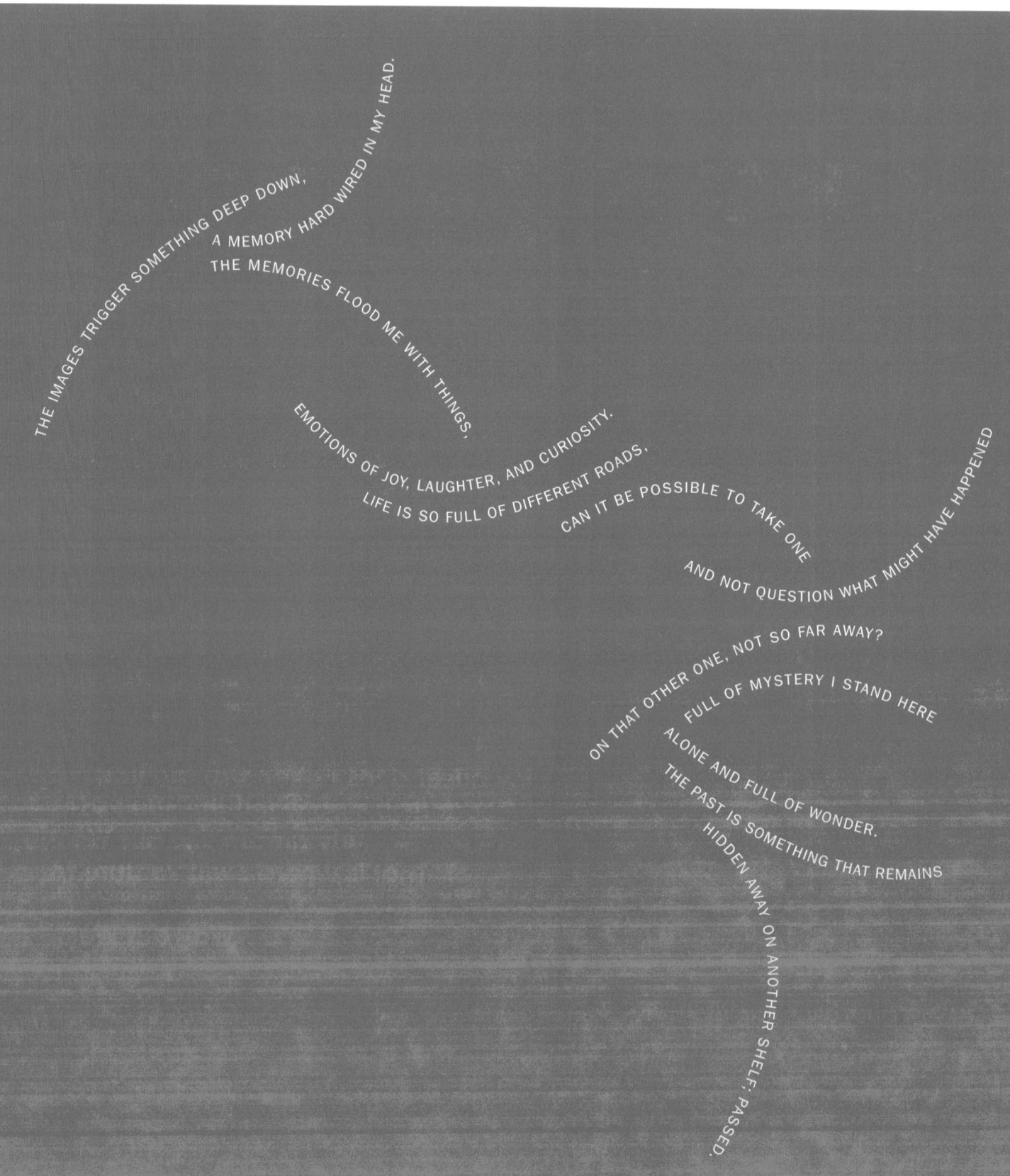

THE IMAGES TRIGGER SOMETHING DEEP DOWN,
A MEMORY HARD WIRED IN MY HEAD.
THE MEMORIES FLOOD ME WITH THINGS,
EMOTIONS OF JOY, LAUGHTER, AND CURIOSITY.
LIFE IS SO FULL OF DIFFERENT ROADS,
CAN IT BE POSSIBLE TO TAKE ONE
AND NOT QUESTION WHAT MIGHT HAVE HAPPENED
ON THAT OTHER ONE, NOT SO FAR AWAY?
FULL OF MYSTERY I STAND HERE
ALONE AND FULL OF WONDER.
THE PAST IS SOMETHING THAT REMAINS
HIDDEN AWAY ON ANOTHER SHELF; PASSED.

PASSED

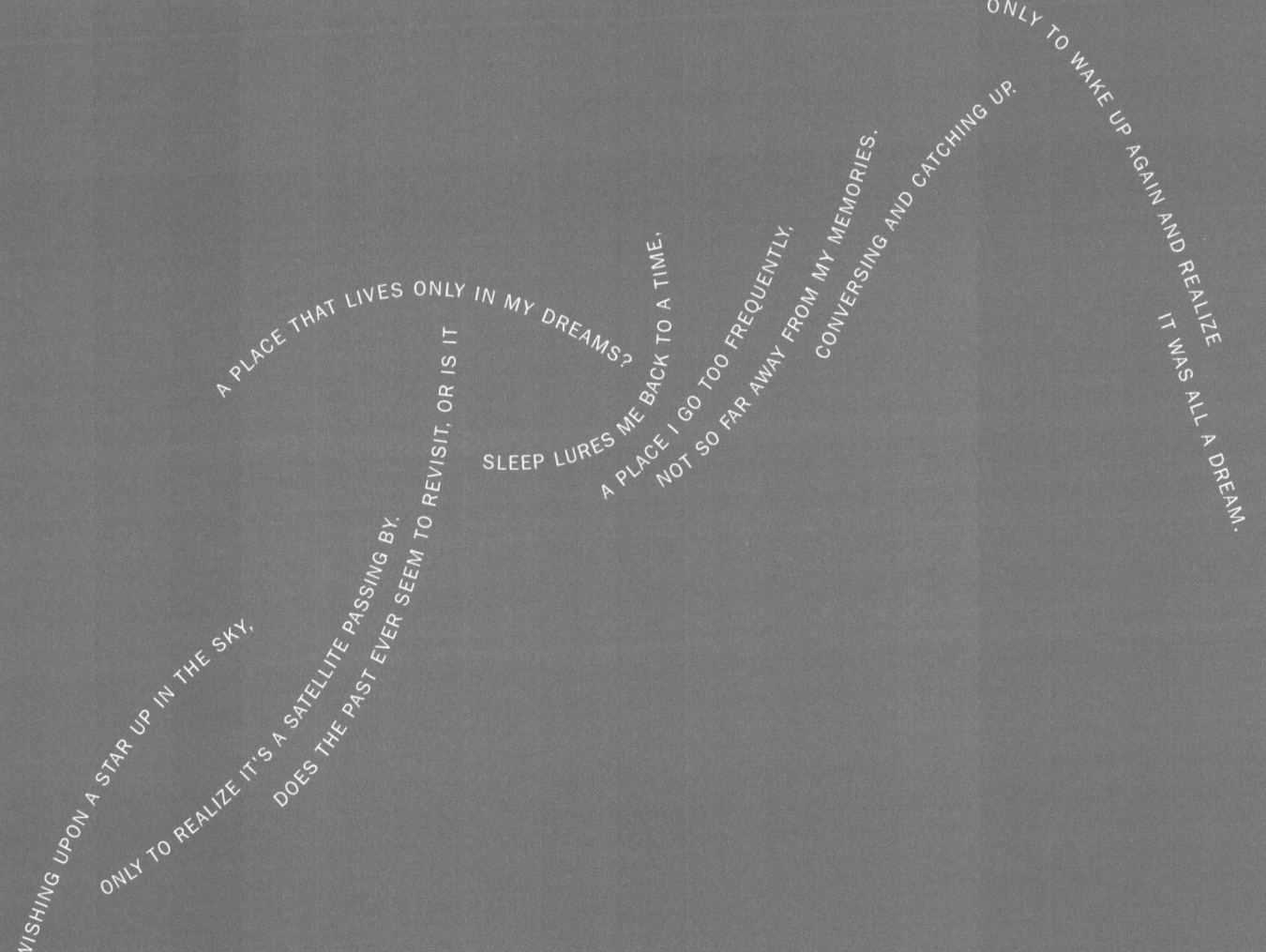

WISHING UPON A STAR UP IN THE SKY,
ONLY TO REALIZE IT'S A SATELLITE PASSING BY.
DOES THE PAST EVER SEEM TO REVISIT, OR IS IT
A PLACE THAT LIVES ONLY IN MY DREAMS?
SLEEP LURES ME BACK TO A TIME,
A PLACE I GO TOO FREQUENTLY.
NOT SO FAR AWAY FROM MY MEMORIES.
CONVERSING AND CATCHING UP.
ONLY TO WAKE UP AGAIN AND REALIZE
IT WAS ALL A DREAM.

Red ꓤed Red

The cloth covers your body
Accentuates your every curve
Sleek and beautiful
The feel of it is like Heaven

I breathe in your skin
Hands on your hips
Feeling them move in the still air
It's like a dream, like it's not a part of me

I stare into your eyes
Piercing blue steel melts my soul
As I can see the love
So much that is between us

Is it something to become more,
Or was it a dream from the beginning?
I still dream of you almost every night
Dreams that I pray won't haunt my memory

So many things that I hope for
Countless things that I have seen
The biggest one, though?
Definitely dancing on an island, just you and me.

Red

The cloth covers your body
Accentuates your every curve
Sleek and beautiful
The feel of it is like Heaven

I breathe in your skin
Hands on your hips
Feeling them move in the still air
It's like a dream, like it's not a part of me

I stare into your eyes
Piercing blue steel melts my soul
As I can see the love
So much that is between us

Is it something to become more,
Or was it a dream from the beginning?
I still dream of you almost every night
Dreams that I pray won't haunt my memory

So many things that I hope for
Countless things that I have seen
The biggest one, though?
Definitely dancing on an island, just you and me.

Midnight Dance

1. The moonlight casts its shadows
 The air smells of salt
 Trees sway in the motionless air
 And waves change the surface

2. To dance in the moonlight
 Underneath the bright stars above
 Nothing could be like it
 How magical a time can be

3. Arms around one another
 Feeling the gentle breeze of the Earth
 Touching your fair skin with my own
 Is almost too much for me to bear

4. Footsteps moving to our heartbeat
 Our souls fall into step and glide
 Across the sand, barefoot
 And the ocean expresses its jealousy

5. The stars encourage us to find
 What we already know lies deep inside
 Staring into your amazing eyes
 Empowers me to embrace all that is

PUSH US BACK AS FAR AS YOU CAN
MAKING US BUST THROUGH THIS WALL
OF FALSE EMOTIONS, DISTRUST AND PAIN
A WALL NOBODY CAN DESTROY

SHAKE YOUR HEAD AND CLENCH YOUR FIST
TO CONSTANTLY DRIVE US BACK
INTO THE SHADOWS WE REMAIN
SOME WAITING, OTHERS GONE.

FEELING AS IF I'M STUCK IN A PAINTING
LIFELESS, MOTIONLESS
A PERMANENT PART OF THE BACKGROUND
DISINTEGRATION OF THE CANVAS IS THE ONLY WAY OUT

BUT STILL, HERE WE ARE
UNABLE TO CRY THE TEARS OF DESPERATION
FIXED, FAR AWAY FROM YOU
ALWAYS AT A DISTANCE.

Surf

Water that breaks over itself,
Pushed by invisible hands
Floating across the surface
Assuring us that old becomes new again

Shifting waters, light breaking through

Calmly I stand here, watching the waves
 Lapping the shore in front of me
 Yearning to flatten the sand
 To erase the footprints from the past
 Taking the debris and washing it away

 Cleaning up the beach, devoid of people
 As the seashells pop up once more

And are swept out to sea again
 We are freeform beings, waiting for our tide

 To wash away the sins
 we have committed
**To help us forget all that
we thought we were**

our
skin

And all is new, again.

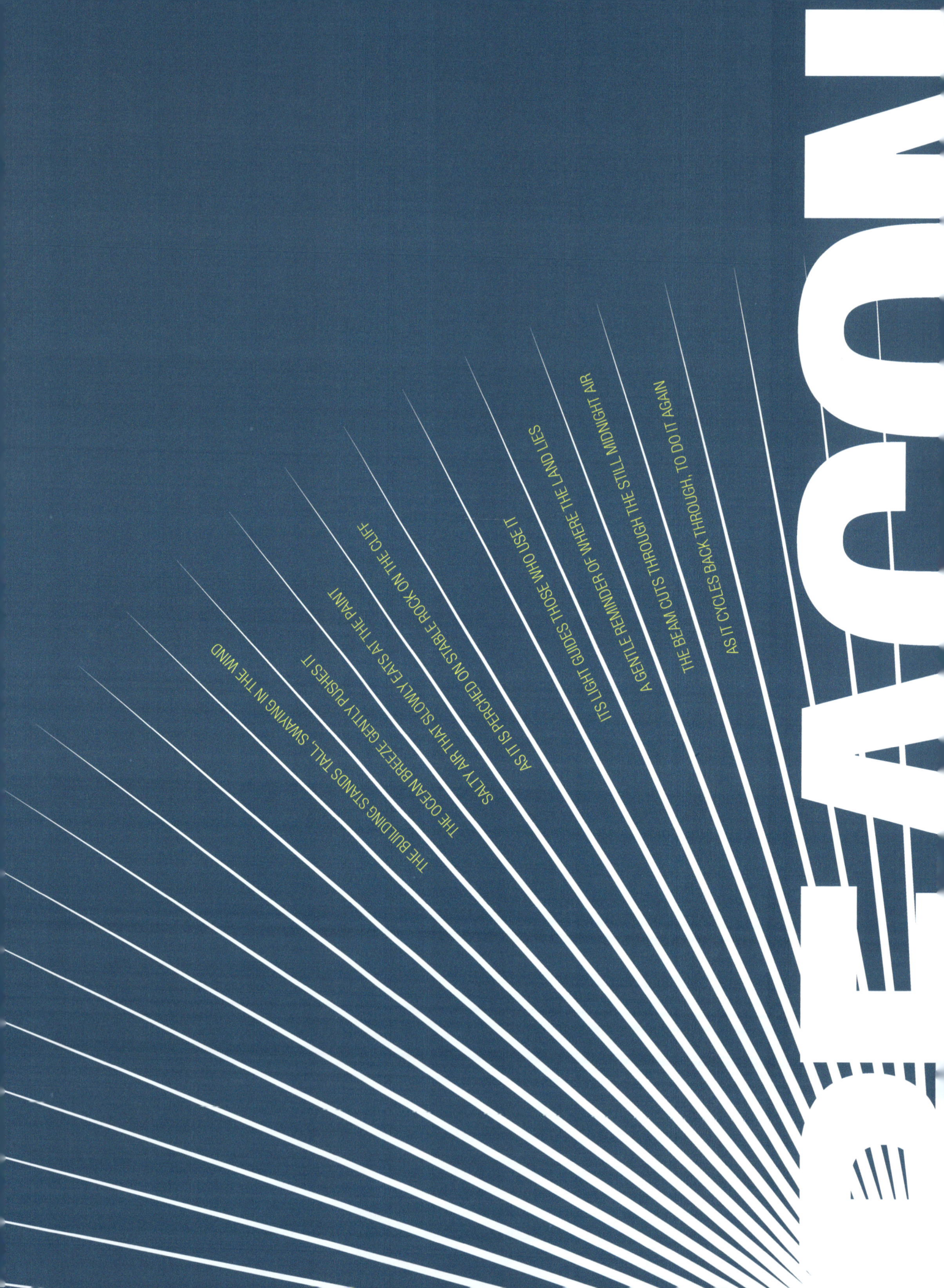

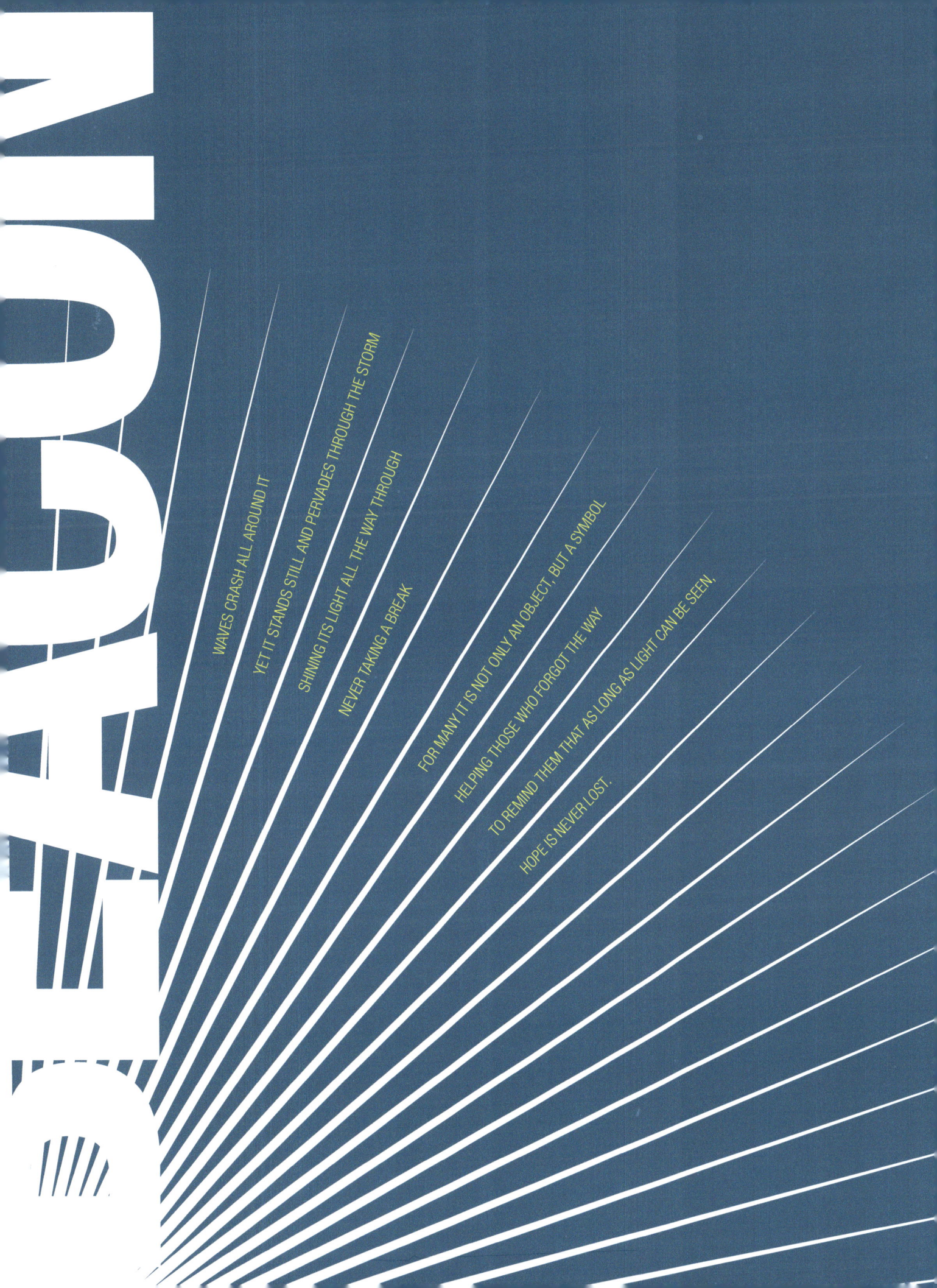

I'M BUILDING A BRIDGE
TRANQUIL WATERS RUSH UNDERNEATH

SLOWLY I PLACE MY FEET
WITHERED WITH TIME

THE WIND PICKS UP
YET STILL I HANG ON

THE LIGHT SHINES FROM THE OTHER SIDE
STRIVING TO REACH IT

EMBRACING ALL THAT LIES AHEAD,
NOT EXACTLY SURE WHAT IT LOOKS LIKE

- TO CROSS THIS RIVER
- BEGGING TO TAKE ME AWAY

- ON THE DELICATE PLANKS
- AND START MY TREK ACROSS

- AND THE BRIDGE SWAYS
- CERTAIN OF ITS STABILITY

- A HOPE I CLING TO WITH CERTAINTY
- AS I HOLD OUT MY HANDS TO TOUCH IT

- WHATEVER IT MAY BE
- BUT I KNOW IT WILL BE WORTH IT

OUCH

THIS IS THE SOUND
OF MY HEART COLLAPSING
UNDERNEATH THE WEIGHT OF ITS OWN
UNABLE TO FURTHER SUSTAIN ITSELF
THE PAIN OF ITS DEMISE
BEGINS TO SCAB OVER
HOPEFULLY HEALING WITH TIME
CERTAINLY DECEIVING MY EYES
I PRAY THAT THE ANSWER IS NOT SO FAR
THAT HOPE CAN BE FOUND
WHEREVER IT IS
I WILL PERSEVERE, AND FIND IT THERE.

(Untitled)

some days I wish that the sea would swallow up the sun and turn every thing into

one.

CRITICAL SILENCE

the MOUNTAINS, steady with stone
NEVER SWAY IN THE WIND
AS THEY *ENDLESSLY* REACH FOR AIR
in the rain they stand tall, ALONE
THE SILENCE SURROUNDS THE WATER
As laps interweave and CRASH *together*
no CITY sounds anywhere near
A SOUND NO FISHERMAN WOULD DARE BARTER
the INCREDIBLE LACK *of* NOISE
driving along the INTERSTATE
staring out the window
such a *LANDSCAPE*, FULL of *POISE*

ALL THOSE WHO *YEARN* FOR *REASON*
stare into their hearts,
SOULS FILLED WITH UNENDING STATIC
until they shut it off, NEVER A NEW SEASON.

Sacro

Rippled clouds

As the sunlight fil

Shadows cast

And everyone strug

The critical sile

Deep within, where

WHAT A HARD

As we continually

The sun eventually

And the water turns

BEAUTY CAN BE FOUND

Even in the way things

The cool breeze stret

And I sit on this crumb

I don't know where

TO TELL EVERYONE WHY IT IS

sanct

pepper the sky

ters through them

upon weary souls

gles to make sense of it

nce can be found

no struggle exists

PLACE TO FIND

try to fill it up

turns everything white

everything to rust

IN THE SMALLEST DETAILS,

are naturally broken down

ches across my face

ling rock, high above

I could possibly start,

THIS WORLD THAT I LOVE.

the course

The road bends and shapes at will
And I have little choice but to follow where it leads
So I give up my preconceptions of what it should look like
Realizing along the way it's better than I could have planned
The transition provides a lovely undertow that drags me along the shore
Unending and certainly unsure of exactly where it will go
The purple, orange, crimson and gold clouds stain the sky's canvass
As the colors fade to one, and the day says goodbye.
Hearts are soaked with burden and disease
But none that eyes can plainly see
We yearn for the things that make us human as we continue
And wonder why it is we never seem to be entirely fulfilled
Everyone runs and stumbles upon the roots of the past
My future is no different, as I look back at things that are gone

My head is filled with regret, longing and nostalgia

As I free my feet and head out to sea once more

The sand is filled with memories of all who have stood here

And as a tribute, I pray that their regrets are set free

As I steadily head towards the rising sun on the horizon

Stretching out my arms to everything that lies within my reach

And even to the things that don't.

2 MILES

THE ROAD THAT I DROVE DOWN TONIGHT WAS LIKE ANY TIME
THE ROAD THAT I DROVE DOWN TONIGHT WAS LIKE ANY TIME
THE ROAD THAT I DROVE DOWN TONIGHT WAS LIKE ANY TIME
THE ROAD THAT I DROVE DOWN TONIGHT WAS LIKE ANY TIME
THE ROAD THAT I DROVE DOWN TONIGHT WAS LIKE ANY TIME
THE ROAD THAT I DROVE DOWN TONIGHT WAS LIKE ANY TIME
THE ROAD THAT I DROVE DOWN TONIGHT WAS LIKE ANY TIME
THE ROAD THAT I DROVE DOWN TONIGHT WAS LIKE ANY TIME
THE ROAD THAT I DROVE DOWN TONIGHT WAS LIKE ANY TIME
THE ROAD THAT I DROVE DOWN TONIGHT WAS LIKE ANY TIME
THE ROAD THAT I DROVE DOWN TONIGHT WAS LIKE ANY TIME
THE ROAD THAT I DROVE DOWN TONIGHT WAS LIKE ANY TIME
THE ROAD THAT I DROVE DOWN TONIGHT WAS LIKE ANY TIME
THE ROAD THAT I DROVE DOWN TONIGHT WAS LIKE ANY TIME
THE ROAD THAT I DROVE DOWN TONIGHT WAS LIKE ANY TIME
THE ROAD THAT I DROVE DOWN TONIGHT WAS LIKE ANY TIME
THE ROAD THAT I DROVE DOWN TONIGHT WAS LIKE ANY TIME
THE ROAD THAT I DROVE DOWN TONIGHT WAS LIKE ANY TIME
THE ROAD THAT I DROVE DOWN TONIGHT WAS LIKE ANY TIME
THE ROAD THAT I DROVE DOWN TONIGHT WAS LIKE ANY TIME
THE ROAD THAT I DROVE DOWN TONIGHT WAS LIKE ANY TIME
THE ROAD THAT I DROVE DOWN TONIGHT WAS LIKE ANY TIME

EXCEPT I ALMOST TOOK THAT ONE TURN
JUST A WAYS DOWN
THAT WOULD HAVE BROUGHT ME TO AN ENTIRELY DIFFERENT DESTINATION

I WOULD HAVE GONE THERE, SMELLING THE SWEET AROMA OF COOKIES
BAKING IN THE OVEN, WHILE RELAXING AND ENJOYING CONVERSATIONS
SEEING IT ALL AGAIN FOR THE FIRST TIME
MADE ME WANT TO TAKE THAT TURN AND RELIVE THOSE MEMORIES

THE NIGHT MAKES EVERYTHING LOOK SO FAMILIAR
WHEN I'VE DRIVEN THIS ROAD A THOUSAND TIMES
BUT NOT IN SO LONG TO GET TO THAT ONE PLACE
THAT I'VE WONDERED ABOUT IN MY RECENT MEMORY

IT'S LIKE A WHOLE OTHER WORLD HAS BEEN SHADED FOR YEARS
PERHAPS BECAUSE I DIDN'T WANT TO SEE IT WITH THESE OLDER EYES
BUT SUDDENLY THAT WORLD WAS ERASED TONIGHT
AS I GOT THE FEELINGS AGAIN OF BEING SEVENTEEN.

WAKING UP

I STAND UP AND RUB MY EYES, BURNING FROM THE LIGHT

YEARNING TO FIND REASON AND COMFORT I LOOK AROUND

AND REALIZE THIS IS A PLACE

THAT I'VE NEVER BEEN TO BEFORE

THE WATER PURER, THE BREEZE LIGHTER

THAN ANY PLACE I'VE EVER BEEN TO

AS I LOOK AROUND AND DISCOVER

I'M ONE OF FEW THAT ARE IN THIS REALITY

EVERYTHING LOOKS SO DIFFERENT HERE NOW

EVEN THOUGH THEIR BASIC SHAPES REMAIN THE SAME

GIVES ME THE FREEDOM TO DO EVERYTHING

LEAVING ME WITH NOTHING

TO LEAD A DIFFERENT LIFE, ALL IT TAKES IS FINDING A DIFFERENT ANGLE

BUT WE KNOW FULL WELL DEEP INSIDE OUR SOULS

- IN THE THINGS THAT WE DON'T UNDERSTAND
- AS WE STRUGGLE TO FIND MEANING
- THE IMPERFECTIONS MAGNIFIED
- SWAYING ONLY SLIGHTLY IN THE WIND, BUT NEVER LOSING THEIR LIGHT
- THAT LINE THE STREETS IN PRECISE SOLITUDE
- AND I LOOK AT THE STREETLIGHTS, AMBER GLOWING BEACONS
- THINGS SEEM CRYSTAL CLEAR AS THE SNOW MELTS
- AS I TAKE IN ALL THAT HAS HAPPENED, ALL THAT IS DEVELOPING
- BUT I LOOK UP AT THE MOON AND SMILE
- THOSE QUESTIONS WE ALL HAVE AT ONE POINT OR ANOTHER
- AS THEY SEEK TO BE AN EXTENSION OF WHO I AM
- WALKING DOWN THE DARK ROADS AT NIGHT LEAD ME TO ASK
- THE HORIZON LINGERS WITH ENDLESS POSSIBILITIES
- AS I STAND IN AWE OF THE BEAUTY THAT SURROUNDS ME
- THE BALANCE IS YET TO BE FOUND BUT CLOSER THAN EVER
- FADING AWAY AS THEIR BRIGHTER COLORS RESTORE MY LIFE
- THOSE OLD FAMILIAR PLACES WHERE I GREW UP AND LOVED

Sometimes words

never go

Where we
want them to,

Expressing to the world

The things we want to say.

Sometimes nothing says it best.

The waters ripple on the pond
Disturbed slightly from below
The wind is still and the air sticks
As the nearby smell of evergreens burn my nostrils

And yet somehow, I feel the presence of something
That I let go of a long time ago
Eerily familiar this feeling is,
One that I never allowed to take its own course

Somehow I am thrust back to the time
Where everything felt so right
And I was sure about the bright burning future
When all of the sudden, everything fell apart.

In turning now to look back at how I felt then
I realize I never allowed it to take its own course
To discover its own path inside of my head
Just as it's once again yearning to do

And now I do my best, as the clouds form in the sky
To let this presence do what it must
In order to bring peace back to my life
And the certainty that nothing lasts, but the future is bright.

And once again, I drive down the road
The one I turned away from in fear many years ago
And decide to just keep driving, to see where it will take me
And I let go of the wheel, because I know I have no control

And I never will.

She sits on my shoulder and talks into my ear

I look up to see her but realize there's no one there

So on I continue, walking along the winding midnight path

Unsure of its destination, but knowing it will be good

Her voice whispering endlessly in my mind

Words can never quite be made out

As the trees constantly filter the wind

And my concentration is broken again

The picture frame sits idle on my bookshelf,
Full of what used to be
And a notion of what might have become
The glass is shattered

Suited to my memories of what it contains
I despise the frame that holds its contents
Though the frame isn't purely physical,
The contents of what was seems to have been

The good times are tainted by some bitter taste
In my mouth that can never quite be washed away
No matter how hard I try or want it to be gone
Some of it always remains

frantic
distant me

And for that very reason I can't ever let you back
Into anything that you thought we were
Because I discovered in the end how fake you were
And it angers me to see that I was such a fool

I'm glad things ended when they did
As the memories I've carried with me now
Are represented in the empty picture frame on my shelf
Destroyed with time

Decaying with every rainfall.

as of a
amorfa

LOOKING INTO YOUR EYES
I MISS THE FEEL OF YOUR LIPS
ON MY OWN, AS WE STOOD THERE
AND KISSED SO EARLY ON THAT DAY
NEVER WANTING IT TO END

Fevereiro 10, 2007

Miami

O ar pegajoso adere-

February 10, 2007

Mia

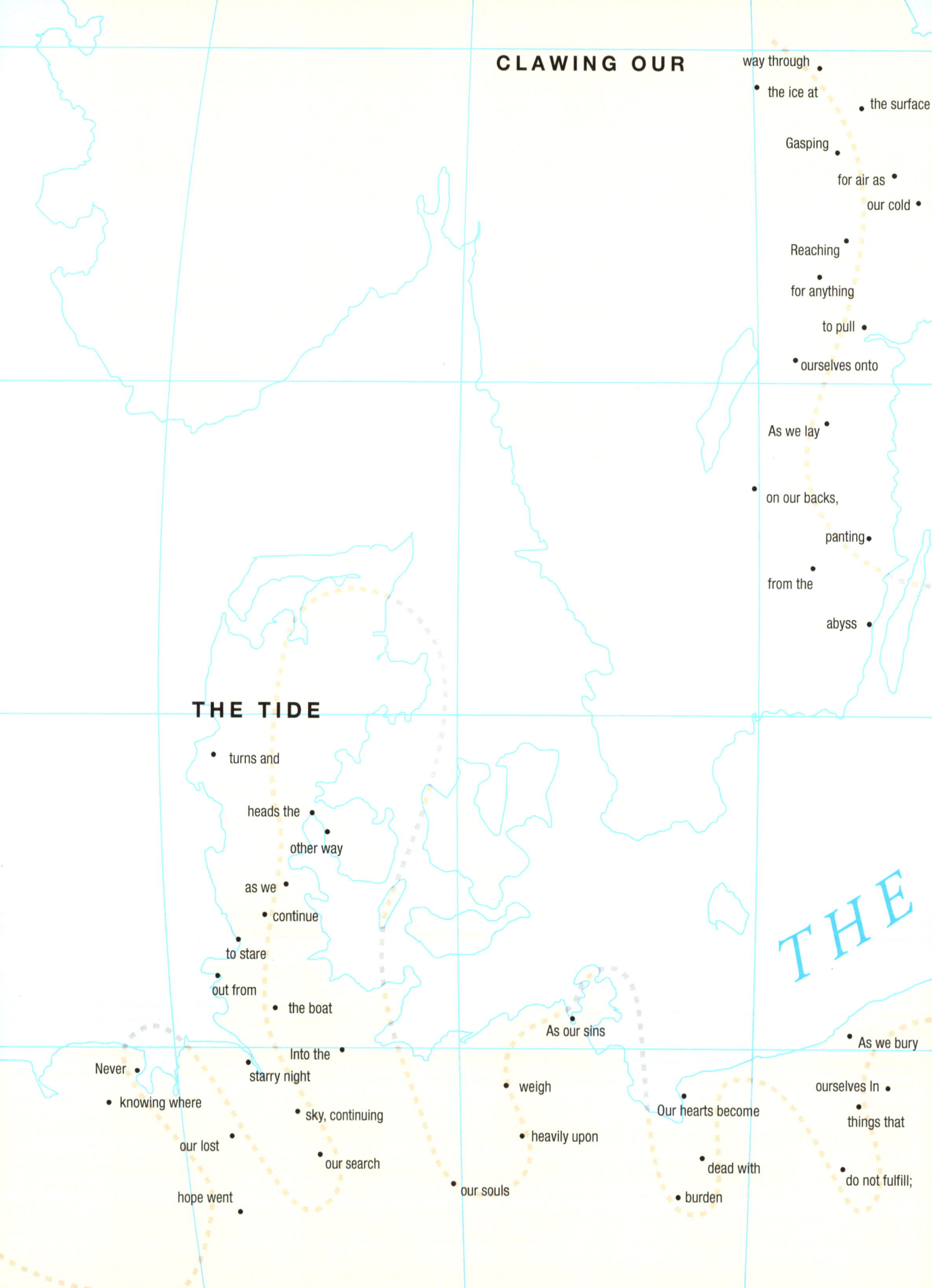

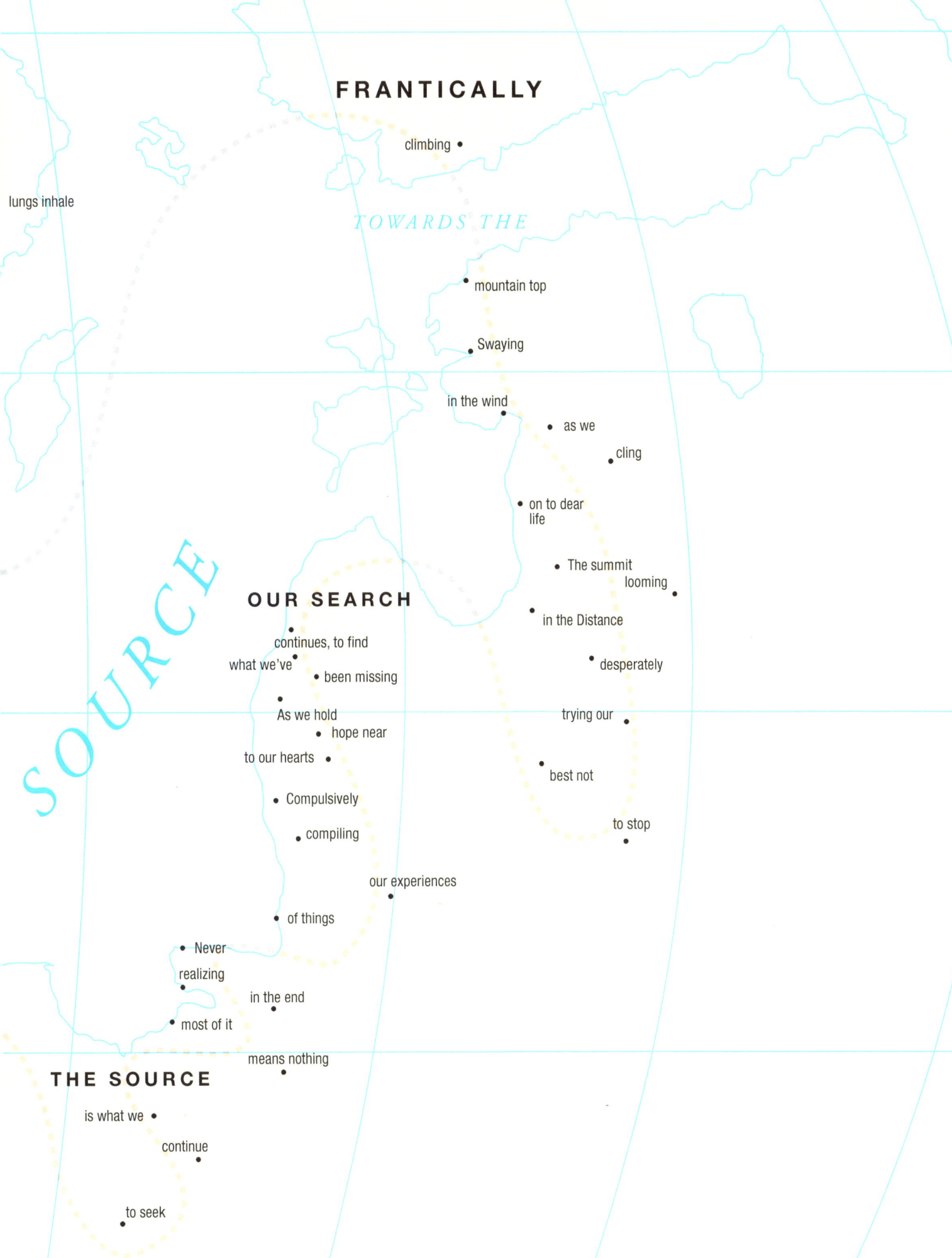

April 16, 2007/ The Half Life of Sense/ The world keeps on spinning/ Revolving its way around the sun/ And we all grasp onto its edges/ Trying desperately not to get burned/ Things make less sense as time goes on/ Decaying on their own on this Earth/ The good few things we have seem to shine/ Only to be destroyed eventually by our own hand/ Sick of the twisted, nonsensical violence/ Never ending in this place we call home/ And we all look to the sky for some kind of meaning/ All that we receive in reply are drops of rain/ There is still a reason to believe that things are good/ And that people may inevitably pull through/ But our selfish nature will destroy any notion of harmony/ As our future generations pick up the pieces/ And try to mend the mistakes that we make/ April 16, 2007/ The Half Life of Sense/ The world keeps on spinning/ Revolving its way around the sun/ And we all grasp onto its edges/ Trying desperately not to get burned/ Things make less sense as time goes on/ Decaying on their own on this Earth/ The good few things we have seem to shine/ Only to be destroyed eventually by our own hand/ Sick of the twisted, nonsensical violence/ Never ending in this place we call home/ And we all look to the sky for some kind of meaning/ All that we receive in reply are drops of rain/ There is still a reason to believe that things are good/ And that people may inevitably pull through/ But our selfish nature will destroy any notion of harmony/ As our future generations pick up the pieces/ And try to mend the mistakes that we make/ April 16, 2007/ The Half Life of Sense/ The world keeps on spinning/ Revolving its way around the sun/ And we all grasp onto its edges/ Trying desperately not to get burned/ Things make less sense as time goes on/ Decaying on their own on this Earth/ The good few things we have seem to shine/ Only to be destroyed eventually by our own hand/ Sick of the twisted, nonsensical violence/ Never ending in this place we call home/ And we all look to the sky for some kind of meaning/ All that we receive in reply are drops of rain/ There is still a reason to believe that things are good/ And that people may inevitably pull through/

April 16, 2007/ The Half Life of Sense/ The world keeps on spinning/ Revolving its way around the sun/ And we all grasp onto its edges/ Trying desperately not to get burned/ Things make less sense as time goes on/ Decaying on their own on this Earth/ The good few things we have seem to shine/ Only to be destroyed eventually by our own hand/ Sick of the twisted, nonsensical violence/ Never ending in this place we call home/ And we all look to the sky for some kind of meaning/ All that we receive in reply are drops of rain/ There is still a reason to believe that things are good/ And that people may inevitably pull through/ But our selfish nature will destroy any notion of harmony/ As our future generations pick up the pieces/ And try to mend the mistakes that we make/

ZERO

SICK OF T[RYING THESE MINDLESS DANCES] AROUND WORDS, THOUGHTS AND FEELINGS THAT ARE PROTESTED LIFE WOULD BE TOO SIMPLE IF WE COULD SPEAK WHATEVER'S ON OUR MINDS AT THE TIME INST[EAD] WHEN ALL I'M LOOKING FOR IS MEANING THAT NEVER SEEMS TO COME CONSTANTLY SEARCHING FOR AN ANSWER OF FEELING LIKE I'M SO VERY TIRED

[...THE GAMES SICK OF THE CRAP TIRED OF FEELING LIKE I'VE GOTTA PLAY TO GET ANYWHERE NEAR ALL I WANT IS FOR SOMETHING TO WORK IN AN UNCONVENTIONAL WAY TO STOP PLA... ...AD OF GUESSING TO HOW YOU SHOULD FEEL AND APPROPRIATELY HOW I SHOULD ACT SUCH A TURN OFF IT IS TO TRY AND WADE THROUGH THESE WATERS OF EMPTINESS AND HUNGER, I GET...]

DEPA[RT]

CARRY YOUR BA[G]
I COULDNT

HOPEFULLY YOULL B[E]
AND DEAL WI[TH]

RTURE

...GAGE WITH YOU
CARE LESS
...ALIZE WHATS GOOD
...TH THE REST

SOME PEOPLE LIVE IN A WORLD
THAT IS BLACK AND WHITE
A DIVIDING LINE TO DISTINGUISH
ALL FROM NONE
LIGHT FROM DARK

BUT THE WORLD IS NOT SIMPLE
IT REVOLVES IN SHADES OF GRAY.

GRAND.FATHER.TIME

JULY 27

AS YOU GOT ONTO THE BUS THIS MORNING
AND SAT NEXT TO ME
I THOUGHT NOTHING OF YOUR APPEARANCE
I'VE SEEN A HUNDRED PEOPLE LIKE YOU

———

BUT AS YOU READ FROM YOUR BOOK
AND I PRETENDED TO BE FASCINATED WITH THE OUTDOOR WORLD
I NOTICED SOMETHING THAT TRIGGERED A MEMORY
A SMELL THAT I HAD LONG AGO FORGOTTEN

———

THAT OLD MIX OF TOBACCO AND WISDOM
AS YOUR BROWN SUITS DOMINATE MY MEMORIES
YOUR KIND WORDS AND INTELLECT MAKE ME REMEMBER
JUST THE MAN I KNEW YOU WERE

———

EVEN THOUGH I NEVER GOT TO KNOW YOU,
THE MAN THAT DAY ON THE BUS REMINDED ME OF YOU
AS 14 YEARS HAD PASSED SINCE YOU LEFT US HERE

AT 10 YEARS OLD,

WHAT COULD I HAVE POSSIBLY KNOWN?

I look back on the 25 years I've spent here so far
And wonder exactly where it will all go
How it will look to someone in 50 years
And if I will be around to see any of it transpire

I can't help, sometimes, but to feel that
All I have here, and all I've ever been
Is nothing meaningful in the grand scheme
That we are all just a moment in time

It doesn't stop me from pondering the future
And planning to make it bright
But I wonder if there isn't more to it
As I gaze out at everything that seems to lie ahead

Sometimes life feels like an accumulation of roads
Stories that we have from different times
Things we will never get back from a time lived
Assembled into a book, gathering dust on a shelf

Will it ever be looked at or wondered about?
Will the things I do here matter in 100 years?
I struggle every day with what my life means
But I do my damndest to give it meaning

Every single day.

YOUR SUMMER COMPLEXION RINGS IN MY EYES

TRYING TO DESTROY MY MEMORIES

AND WALK THE PATHS WE'VE BEEN ON BEFORE

AS I BREATHE IN THE AREAS WE USED TO LOVE

I'M CONTINUALLY HAUNTED BY EVERYTHING THAT WAS

BECAUSE I HAVEN'T FOUND ANYTHING LIKE IT SINCE

AND WONDER WHEN I WILL,

OUR WORDS TODAY MATCH THE ONES WE HAD BACK THEN

AS WE HAVE TO REALIZE THAT WHAT WE HAD IS NOT DEAD

IF FOR NOTHING ELSE

THE VERY FACT THAT IT USED TO BE WHO WE WERE

I THINK WE BOTH KNOW THERE IS NO FUTURE BETWEEN US

BUT REALIZE THE FUTURE SEEMED GREAT AT THAT TIME

AS OUR TIMELINES HAVE SHIFTED, AND SEVEN YEARS LATER

MY MEMORIES OF LIFE WASH ASHORE

AS I REMEMBER WHAT IT WAS LIKE TO BREATHE YOU IN

THESE SUMMER DAYS

IF I EVER GET BACK TO THAT SPOT

I SIT HERE WONDERING WHEN IT WILL ALL FADE

THE SURF NEVER TOUCHED OUR SKIN

BUT THE SUN SET ABOVE OUR OCEAN

GEARS of LIFE

How can anyone sit there
And not feel something greater at hand?
Looking behind everything in life
There is always a bigger set of gears

The curtain is pulled away
As the horizon cusps the sun
Air swallowed is forgotten
By our very own lungs

Seeing underneath the ground
And the smallest things that go around
Gives the sense that we are not alone
How could we possibly think so?

Everything is recycled eventually
And all will be turned to ash and dust
As we sit in our vessels, so far away
And gaze in awe at everything we never made

COLLAPSE

Sitting here looking at the beautiful sunset
Glorious simply because you are not a part of it
The weight of the traffic on the road is more and more
I don't like the load that I've been destined to bear

Eventually the engineering collapses
And we are left with shadows and fragments
Of things we used to call home and treasure
Simply because time will destroy everything

The façade of mankind will someday fall
To reveal what was always behind the curtain
And we look upon it with fresh eyes once more
Only to realize the true beauty of it all

And as we rotate with the wind
With gravity suspending us and holding our dreams
We capture everything that was meant to be
For everything is better than it seems.

www.ingramcontent.com/pod-product-compliance
Lightning Source LLC
Chambersburg PA
CBHW051028180526
45172CB00002B/503